LIZ RIDEAL **STILLS**

Essays by
Norman Bryson and
Charles Darwent

Photo-booths have a fascination all their own. It seems as though they should have all disappeared long ago, that they belong to an antiquated predigital era. Certain clues point to a lost paradigm involving quirky intersections between automation, mass society, and the individual both conforming to the pressures of mass society and resisting them.

The photo-booth portrait is a likeness snatched from the effacement of individuality that occurs when that individual merges with and disappears into the urban throng. The format is totally automated: there is no altering the set lighting levels in the booth, the focus, the exposure time, or the interval between the four flashes. When the tiny images emerge at the other end, they are accompanied by none of the niceties that are observed when you collect photographs from the developer, no folder or envelope or seductive enwrapment.

The accent is on industrial repetition: a single image would belong to a world presided over by the individual, but here the face is dis-individuated, subjected to an order of four exact repetitions, reduced to a cipher. What the photo-booth represents to its user is the fate of normalization, standardization, massification. Hence its economic alliance with passport offices: what each of the four frames signals is the subject's successful absorption by the forces of law and order.

Yet that is, of course, only half the story: for each user hurrying to get to the passport counter there is another in a state of mild mutiny against disciplinary regimes. If the photo-machine seems to anticipate the facial expression of a docile civil subject, that is precisely the expression to be avoided. The booth becomes the scene of a Lark. That discreet pull-back curtain allows the user just enough privacy to go into closet carnival mode. Though still in public space, there may be room for just a little anarchy. Normalised, disciplined? Not me! Now the photo-booth is about vitality, singularity, dissidence. How about a compromise? Two for the passport office, and two for your friends? Give to Caesar what is Caesar's, but that done, have a bit of fun as well.

The photo-booth is the site, then, of two very contradictory impulses and sets of behaviour: public and official order, tending toward anonymity and blankness; and secret rebellion. The booth becomes part of everyday

1. Eadweard Muybridge (1830-1904)
Tigress turning around, 1887
Plate 730 from 'Animal Locomotion'
He was the first photographer to carry out the analysis of movement by sequence photography.
National Museum of Photography, Film & Television/Science and Society Picture Library

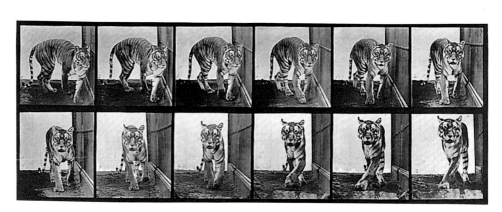

tactics for defeating your own internalized conformity. The beauty lies in the social invisiblity of the whole process: the perfectly hypocritical machine.

What happens, then, when the products of the photo-booth are transposed to the domain of art? For that is Liz Rideal's opening move, one whose extraordinary consequences her work continues to trace. It is as though the split between official propriety and secret dissidence were now elaborated and amplified, made deeper and more complex, on the gallery walls.

What enables the transposition into art is the discourse of the Grid, one of the most venerable and formidable among the tropes of modernism. In the words of Rosalind Krauss: "in so far as its order is that of pure relationship, the grid is a way of abrogating the claims of natural objects to have an order particular to themselves".* When placed within a grid, no matter how specific the represented object may be, a higher order moves in and substitutes for singularity and uniqueness a logic of standardization and taxonomy. Think of Muybridge (1): though each frame captures a specific pose of the figure, perception of the individual frame is now routed through the adjacent members of the photographic series. Or think of the Bechers: however distinctive the depicted object may be in itself - coal bunker, water tower, silo, when rendered as a part of a taxonomy, its definition no longer comes from itself, but from its differences from the rest of its class. In other words, the external or referential relation (between the photographic image and the original object in the world) gives way to the internal and abstracted order of seriality: the grid assaults mimesis, it breaks the bond the

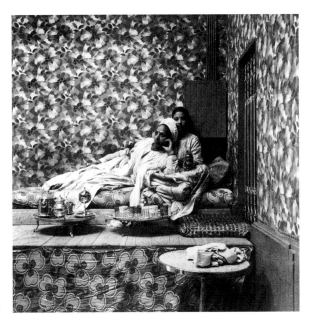

2. Cecil Beaton
(1904-1980)
Moroccan Women
photograph courtesy
of Sotheby's London

image has to the world, it transposes the object into the autonomous realm of art.

The autonomy-effect can be pushed still further if it is accompanied by strategies designed to evacuate the referent, whether by tautology (reprinting the same image again and again), or banality (choosing objects with little or zero degree of value as spectacle), or enigma (why that referent, of all things? why gas stations? why the waves of all the world's seas? why an interior? (2)

Taken one way, Liz Rideal's images subscribe to the protocols of autonomous art to the letter. Resolutely deductive, the total image is an exact multiple of its individual elements. Individual units vanish into the all-over surface. It becomes difficult to isolate or focus on any one tessera: the eye loses its grip on the tiny photobooth image, lets go, and attends instead to pools of unfocussed, peripheral vision. New kinds of rhythm and pattern emerge that have nothing to do with the order of the single image - pulsations, flickerings, op effects occurring at the macro, but not at the micro, level. It seems as though the whole image is built on tautology: surely this is the same image of a root, repeated an endless number of times?

* Rosalind E. Krauss, "Grids" (1978)
The originality of the avant garde and other modernist myths, Massachusetts: MIT Cambridge, Massachusetts/London, 1985 (1986)

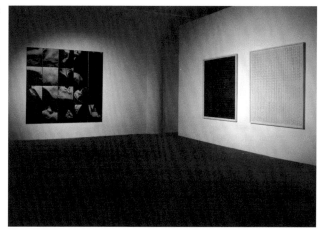

3. Installation view: exhibition August 2000, Lucas Schoormans Gallery

ely enough, every frame is as singular as a hand-painted miniature. Though at first sight it may seem as though Rideal's surface repeats the same image hundreds of times, in fact each unit is a one-off. There is neither repetition nor repeatability.

This radically revises the all-over surface that seems to govern her imagery. The grid is isotropic: each area possesses the same, identical properties. By the same token the grid is a simultaneous structure, with all its parts co-existing in the same non-duration-al temporality of the all-at-once. But Rideal's grids belong to a real-time process. The interval between the four flashes inside the photo-booth cannot be changed. An image made from, for example, 406 strips of four (making a total of 1,624 individual pictures) would have taken around 34 hours to produce. The temporal order here is resolutely that of succession, not simultaneity. And spatially, since no repetition is actually involved (there being no negative stage), the indi-vidual photogaph is never truly subsumed into a higher totality. The moment of abso-lute singularity is never surpassed. To that extent, there may be no abstraction, at all.

Rideal's work from 1998 (3) shows endless-ly repeated sections of fabric, as though the overlooked element of the classical vocabul-ary of art, drapery, had moved centre-stage: the force of enigma is never far away.

Rideal's photo-collages follow a sufficient number of the tropes of modernist abstract-ion – the grid, tautology, enigma – for us to know that this is the language that is being evoked. The goal seems clear enough: to create abstraction via a radical break bet-ween the image and the real world; to produce a culture of high art able to break away from mere imitation and from the debased social conditions of mass-cultural modernity.

But the photo-booth is a profoundly duplici-tous image-machine. In what ways does Liz Rideal unravel the noble, modernist grid? First of all, it is not a grid at all, not in the sense intended by Krauss. It is true that the whole surface is traversed by lines, and that may be enough to suggest an even, all-over surface in which all areas are equivalent and interchangeable, and ultimately derived or deduced from the frame. Yet the peculiar-ity of the photo-booth is that it employs a process of image-production that omits the stage of the photographic negative. Negativ-es always harbour the idea of replication: from a single negative there can be generat-ed an infinite number of prints. But each image from the photo-booth is unique. Strang-

In the classical formulation of the genres of painting in Reynolds' Discourses* of the 1770's and 1780's, he consigned still life (4) to the lowest position in the hierarchy of genres on the grounds that it interfered with the painter's access to central forms, those products of the mind's generalising powers. At the summit reigned history paint-ing, centred on the human body: familiarity with the forms of the body permitted the mind of the painter, by comparing innumer-able instances of the human form, to ab-stract from it those typical or central features that represented the body's essence or ideal.

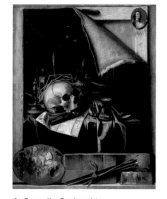

4. Cornelis Gysbrechts (active Antwerp c.1659 - c.1678) Vanitas (Still Life - Trompe l'oeil) 1664 Ferens Art Gallery: Hull City Museums & Art Gallery

*Sir Joshua Reynolds, Dicourses on Art, ed. by Robert R. Wark, Yale University Press 1975 p. 51-2

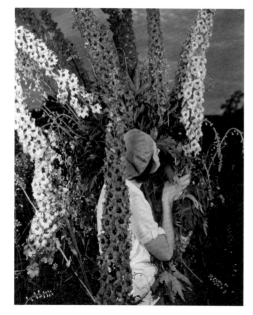

5. Edward Steichen (1879 - 1973)
Woman with Delphiniums,
House & Garden June 1933,
Edward Steichen/© House & Garden,
Condé Nast Publications Inc.

and Angelica Kauffman). The moment we recollect how these images are produced, the simultaneity of the grid gives way to duration, succession, and real-time process (including the many hours spent constructing the work). We then recall that these cameras bypass the negative and the all-over morcelizes into hundreds of tiny independent units that resist unification.

Counter-grids, therefore: going with the flow of the civic, high modernist claims for art, but secretly resisting and subverting that whole project, moving into an anti-official, carnival universe of singularities. Rideal's photo-booth can be a great place to use the means of modernity against its own ends. ■

Liz Rideal's grids of flowers enact this Reynoldsian drama in highly duplicitous fashion. In a sense they take the very emblem of overwhelming detail, the representation of nature, (5) and sublimate it into grid-like abstraction. The points of detail that existed at the level of the individual image are subsumed into a much higher order: now the mind – Reynolds would have been pleased with this – takes in hundreds of instances, transcending the detailed unit and moving to the conceptually superior space of Becher-like or Muybridge-like comparisons. Transposing singularity and specificity into the macro order of the all-over composition, Rideal's works are raised to the level of history painting, the highest and most abstract of the genres in Reynolds' day, as the grid has perhaps been in our own time.

Taken yet another way, this elevated and ennobling enterprise is altogether subverted. The moment one realises that each image belongs to a strip of four, the all-over surface breaks up into blocks, (6) collaged together with patience and dexterity, not unified by an act of transcendental intelligence (in the mind of the eighteenth century Reynolds, a specifically masculine intelligence. Flower painting he conferred on his colleagues at the Royal Academy, Mary Moser*

6. Liz Rideal
Gualala Dawn, 2000
photo-booth strips on board
32 x 25 1/4 inches

*Peter Mitchell, European Flower Painters, London 1973, pp.182-3 & pl.257

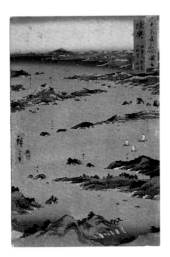

1. Utagawa Hiroshige (1797-1858)
Matsu Province:
Scenery at Matsushima.
College Art Collections,
University College London

Last April, Liz Rideal and I spent a week in Kyoto. For Rideal, although she had never been to Japan before, the trip was something of a homecoming. For years, she'd been fascinated by the way the Japanese – citizens, like the British, of a small island anchored off a large continent – had coped with the idea of smallness.

The traditional British answer to the problem has been to look outward, to imagine the grandiose. The art of Britain has been the art of imagined bigness, and hence of big imaginings: Constable's distant prospects, Turner lashed to the mast, Blake's ghostly fleas. Faced with the same constraints of size, the Japanese have arrived at precisely the opposite answer: a cult of inscape rather than of landscape.

This aesthetic has bred its own rules. The god of Japanese art is the god of perversely small things. The famous *kare-sansui* – or Buddhist dry gardens – of Kyoto's Daitoku-ji temple are not about the model-village thrill of finding yourself a giant in a miniature world. (Still less do they have to do with galumphing words like "abstraction" and "minimalism".) Rather, they are about the dynamics of completeness and containment: the quiet wonder of being able to see an entire scene, and all its interrelations, in a single glance and moment.

It wasn't primarily the gravel seas and boulder islands of Daitoku-ji that caught Rideal's imagination in Kyoto, though. What really intrigued her was the warren of streets around Nishijin, an old artisanal quarter still lived in by silk-weavers and textile workers. The odd thing about the houses in Nishijin is their inwardness. There is no feeling of planned development to the streets and no

house-numbers; no assumed communalism, no neighbourliness. Stroll down an alley and you are left with a strong sense of being excluded from its inner life, although with an equally strong sense of the inner life from which you are being excluded. Façades are blank, like sex shops or bookmakers. What you are allowed to see, by and large, are the unadorned backs of things: a grill behind a frosted pane behind a paper blind behind a screen.

You can see where the appeal might lie for Liz Rideal. Like the *kare-sansui* gardens, the point of Nishijin's domestic architecture is not so much its embracing of smallness as its ritualising of the rules of smallness. The Japanese take on domesticity is an exact inversion of the Englishman's idea of his home as a castle, a piece of fancy that relies on finding grandeur by looking outwards across imagined acres to a fictive horizon. Scale in Japan works the other way around, being measured internally from obscured windows rather than externally through them, in units of tatami mats rather than of distance. Consequently domesticity itself becomes a great thing, a drama of self-containment.

The similarity of all this with photo-booth photography is obvious. When she first started experimenting with the medium fifteen years ago, Liz Rideal was struck by the way in which the photo-booth turns theatre inside-out. Instead of the collective experience of being spoon-fed revelation in an amphitheatre, the excitement of the booth lies in curtaining yourself off from the crowd in a public place. It's a subjective rather than an objective process, with yourself as the subject and your own tiny dramas as the narrative. It's a comic medium, and yet (as

anyone who has looked with horror at that strip of four vampiric mugshots will know) part of the comedy lies in the essentially tragic fact that we seldom get what we think we deserve. We invent the machine, we pay it and suck in our cheeks for it and it does whatever it likes.

This might lead you to assume that Rideal's fondness for the photo-booth is ironic in some way. Her subjects however - garden flowers and drapery - are the stuff of still lifes and history paintings, High Art. Given that the function of the photo-booth is the making of portraits (another High Art pursuit), her exclusion of the figure in favour of what looks like consciously inappropriate subject matter suggests something in the way of subversion: particularly so, given Rideal's long association with London's National Portrait Gallery. Perhaps the artist is saying Warholian things about the pointlessness of demarcations between High and Low Art in an age of mechanical reproduction; perhaps something about the banalising power of photography. Perhaps her work is a Luddite stand against the mechanistic nature of the modern world, perhaps all of the above.

Or, perhaps, none of them. When I asked Rideal to provide images to accompany this essay, she wordlessly produced the following: Utagawa Hiroshige's *Matsu Province: Scenery at Matsushima* (1); an etched alphabet of hand-gestures from John Bulwer's 1644 manual on rhetoric, *Chironomia*; a black-and-white photograph of a shuttered window in her French grandmother's apartment in Paris (4.); a postcard of Henri Fantin-Latour's *Spray of Purple Lilac* from the San Francisco Legion of Honour Museum; a Madonna and Child by Dirk Bouts (3.); Etienne-Jules Marey's photograph of plumes of smoke wafting around a curved surface; and a stereoscope card of Japanese women at an Edwardian flowershow in Yokohama entitled "Four Little Maids Are We"(2).

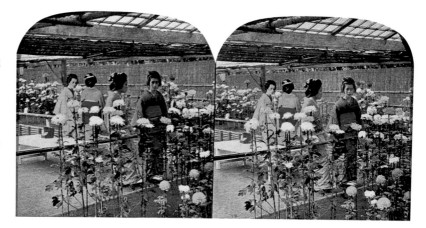

What can we deduce from this choice? The Fantin-Latour and Bouts suggest that Rideal chooses her subjects not so much for their beauty as for their painterly quality. Her work is the same as, but different from, that of her mentors: a new look at an old idea, an act of homage that is intended to make us re-notice both the thing that is being praised and the means of its praising. Bulwer's rhetorical tract and Marey's photograph show the artist's fascination with the grammar of movement, and with the way that grammar can be abstracted into a visual code. The four Japanese maids are also about optical languages, conventions for codifying things like stereoscopic vision.

It is the last, and perhaps most unlikely, pairing of a Paris window with a Hiroshige landscape that tells you most about Liz Rideal's work, though. For one thing, it introduces a biographical note to her images. Rideal's exclusion of the human figure is not complete. The artist's hand makes an occasional ludic appearance in the frame,

2. Unknown photographer
Four Little Maids Are We.
At the Chrysanthemum Show,
Yokohama, Japan.
Stereoscopic print

Katsushika Hokusai
(1760 - 1849)
Kakegawa.
From the 53 Stations of the Tokaido Highway.
College Art Collections,
University College London

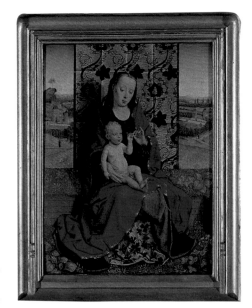

3. Dirk Bouts (c. 1415 - 1475)
Madonna and Child
Sir Thomas Barlow Collection on loan
to Kenwood House, London
English Heritage Photographic Library

stressing the accidental nature of what we commonly think of as a mechanical process, but also playing a quiet game of cat-and-mouse with the idea of authorship. In the same way, her proffering of her grandmother's window suggests a reason for her empathy with the Japanese aesthetic of enclosure – an aesthetic that finds its ultimate expression in *Matsu Province: Scenery at Matsushima*.

Look at Hiroshige's woodblock print and you will see the same inversion of Western thought as you do in the streets of Nishijin. Were the work to have been made by (say) an English contemporary of Hiroshige's, its point would have been a recession into depth. Hiroshige, by contrast, stresses the verticality of his picture, using a portrait rather than a landscape format and inviting an up-down reading against a flat picture-plane by colouring his perspectival foreground and background in the same dark blue.

Like the obscured windows of Nishijin, his picture rejects the overblown significance of horizon in favour of a smaller drama which is codified, complete and self-contained. And that same drama is the one we see being played out, again and again, in Liz Rideal's work.

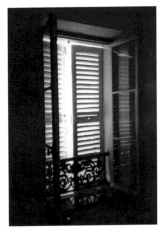

4. Liz Rideal
Le Balcon, Rue Legendre, 1993

If you were to find a single word to define the spirit of that work, the word might well be "politesse". This is not to suggest the well-bred lifting of little fingers or the distant clink of tea-cups. Rather, Rideal takes on board (even cultifies) the whole idea of rules, taking the obvious perameters of her medium and playing with them, weaving them into the fabric of her art. Robert Frost compared the writing of free verse to playing tennis without a net. Rideal's art starts from the same position: that rules are there as an essential part of the game, to be embraced rather than discarded.

Take any work here, for example the *Fantin-Latour Homage*. The point about photo-booth photographs is that they are neutral, alike and taken in a strip: mechanistic, if you like, with none of the hand-made quality and authenticity that we now value in a painter like Fantin-Latour. Rideal's *Homage* out-booths the photo-booth, presenting us with not four but four dozen identical images, arranged in a grid so strict that we are torn between reading the end result as a collection of tesserae or as a single, abstracted work.

And yet it is precisely Rideal's observation of these rules that introduces a deeper tension into the picture. In fact, her grid is not as strict as it seems. Tiny differences; the inversion of alternate photo-strips and the variations in lighting, set up rhomboidal rhythms in the work that bring to mind the Op art work of Briget Riley. Slivers of frame, a sign of enclosure, can as easily be read as connective tissue in an overall pattern. The photo-strips are both a pictorial medium in their own right and a material in the making of pictures, woven together like quilting. And behind all of this is the playfulness that

bent the rules in the first place by putting a High Art subject in a Low Art setting; and creating an obscure narrative.

For all the playfulness of this process, though, there is nothing of BritArt glibness in Rideal's images. Suggest an ironic reading of her work and she will deny it: instead, she talks about the painterly finishes achievable with a photo-booth, the beauty and precision of identical repetition. The obvious analogy is with a musical instrument, a machine for the making of art. Nor does Rideal's exclusion of the human figure, and particularly of her own figure, from the frame suggest any kind of aloofness from her process. She is in all her pictures, her own daily drama is as much a part of them as if she were using the booth for its more normal purpose.

This is especially apparent in her latest large-scale prints blown up from ten by eight colour negatives of photographs made directly from her original photo-booth images. Photographs of photographs, portraits of portraits: it's a very Japanese game, which is to say, it's a game of rules.

Mask: Runner Bean is, in terms of Rideal's usual practice, verging on the Baroque. Quite apart from the question of scale, the clogged roots of its subject have a (literal) earthiness that seems shocking against the picture's white muslin background. Rideal has used the set focal length of a photo-booth, producing areas of blurring, to reinforce the sense of three-dimensional modelling in her image. This creates a Hitchcockian drama. And yet the real drama comes from the fact that – for all their seeming to defy physics – these are clearly photo-booth pictures, with ghostly frames and a flat,

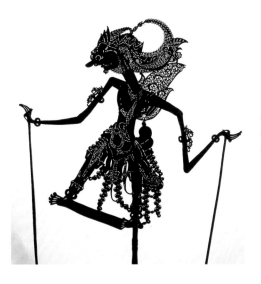

5. Javanese shadow puppet
Science Museum/Science and Society Picture Library

neutral, narrative reminiscent of Hiroshige. They are impossible but credible, unlikely yet seductive.

Part of Rideal's fondness for the photo-booth is not formal but nostalgic and in that sense autobiographical. The booth is a place where we record banal things and, in recording them, make them special. One of the new works is called *Sunny Gardens* after the name of the suburban road where the artist spent part of her early life. Another, *Wyang Kulit*, takes its title from the Malay shadow-puppets (5) that Rideal saw during a time spent in Singapore as a child. Her fascination with the puppets, now as then, came from the way their shadows were both back-projected onto a sheet and distorted by it: contained by enclosure and created by it. Without that personal drama, you might see Rideal's work as tricky or obsessive. With it, it's extraordinary. ■

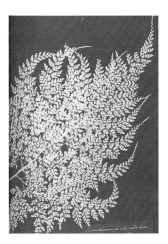

6. Anna Atkins (1799 - 1871) and Anne Dixon (1799 - 1864)
British Fern, 1853
Cyanotype.
Science Mueum/Science and Society Picture Library

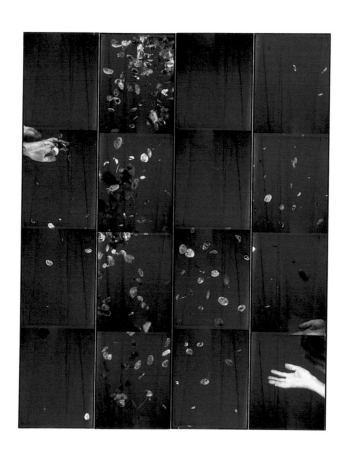

Honesty, 2000, photo-booth strips on board, 7 7/8 x 6 1/4 inches

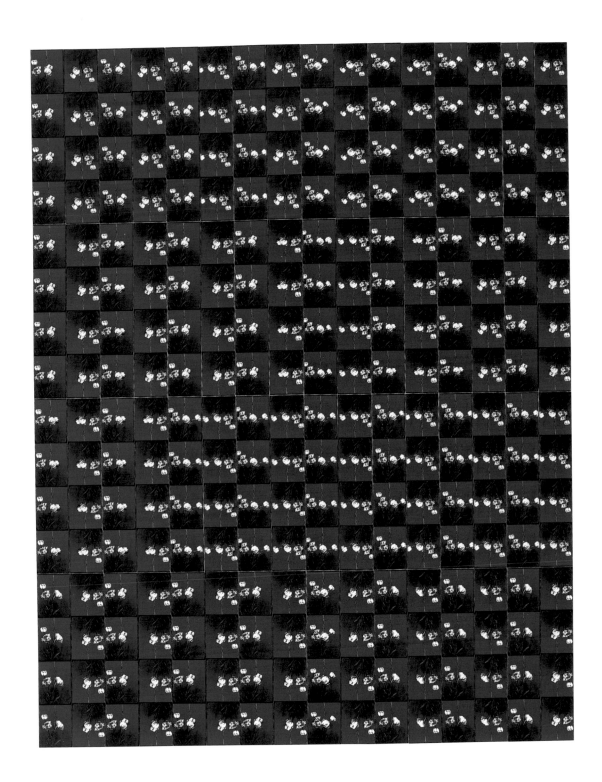

Dutch Tulip, 2000, photo-booth strips on board, 32 x 25 1/4 inches

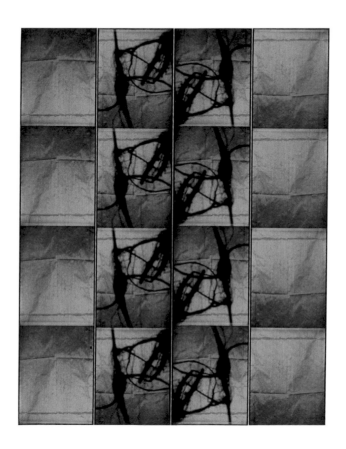

Stained Glass Masquerade, 2000, photo-booth strips on board, 7 7/8 x 6 1/4 inches

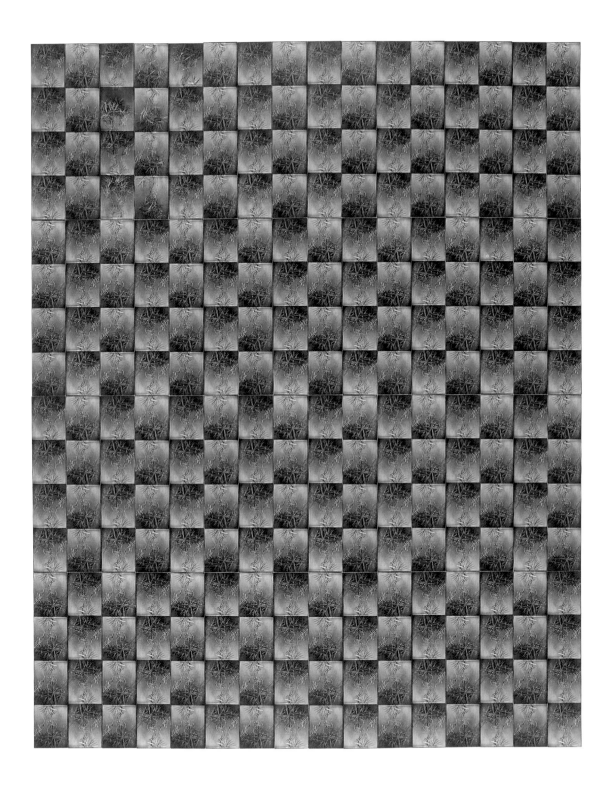

Air Force Urchin, 2000, photo-booth strips on board, 32 x 25 1/4 inches

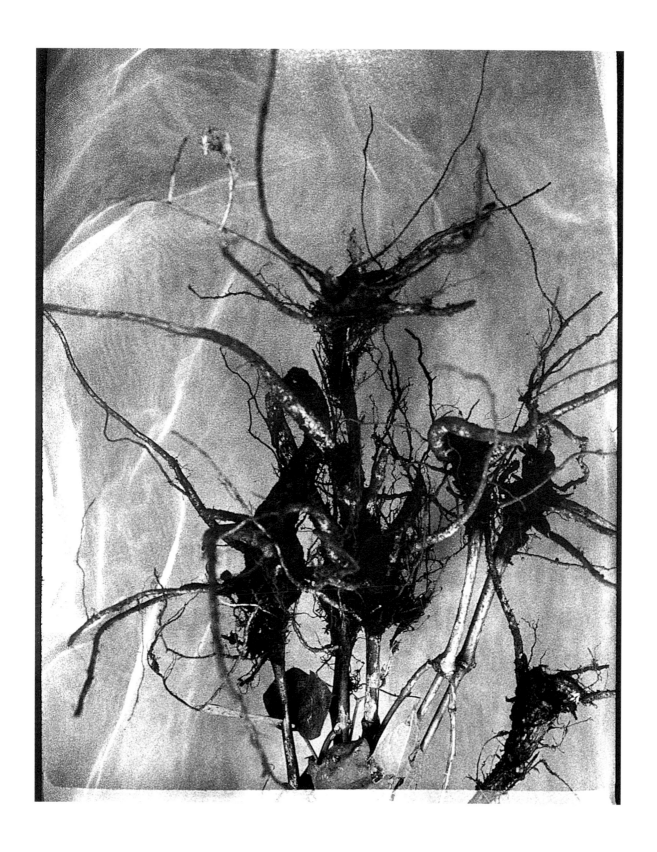

Mask (Runner Bean), 2000, C-print, 60 x 48 inches

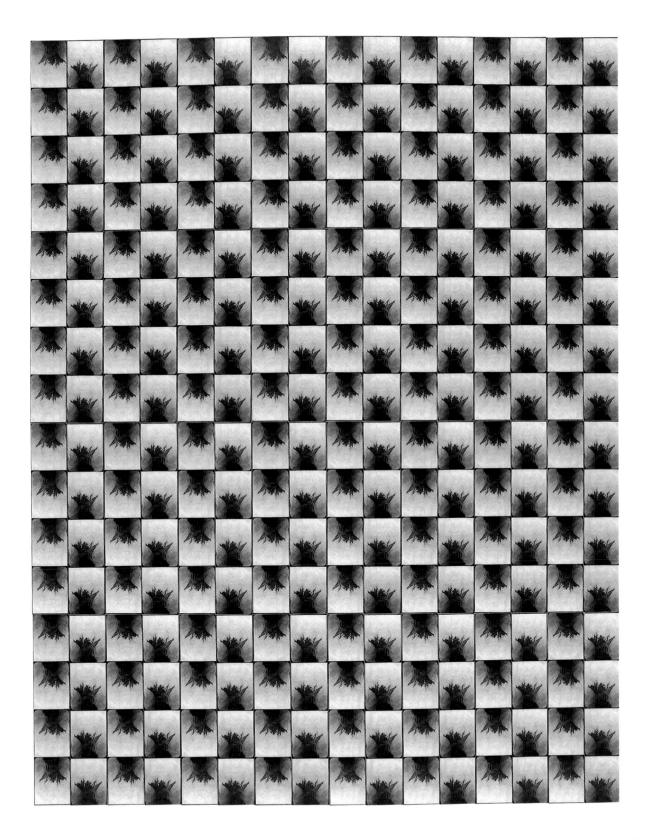

Princess Lily, 2000, photo-booth strips on board, 32 x 25 1/4 inches

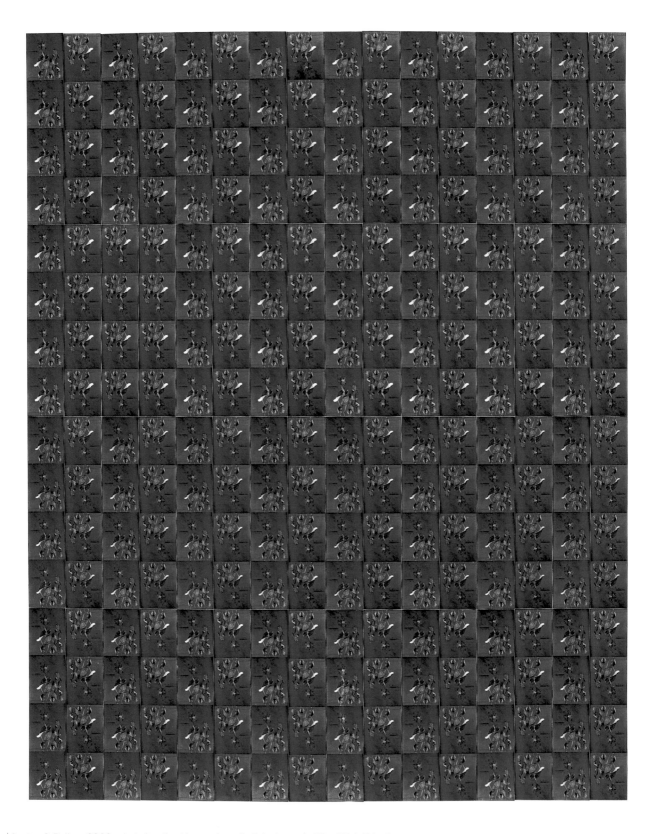

Castor & Pollux, 2000, photo-booth strips on board, diptych, each 32 x 25 1/4 inches

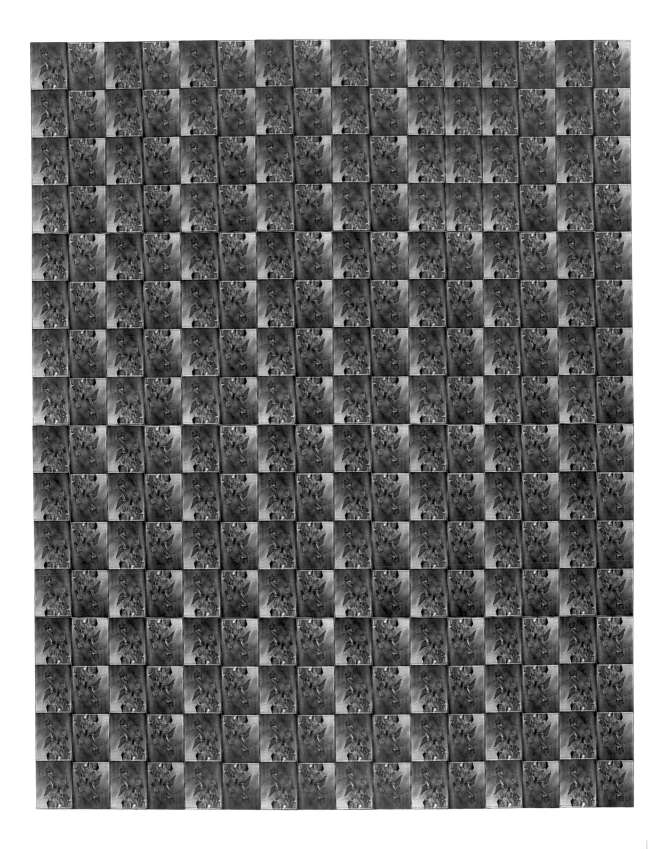

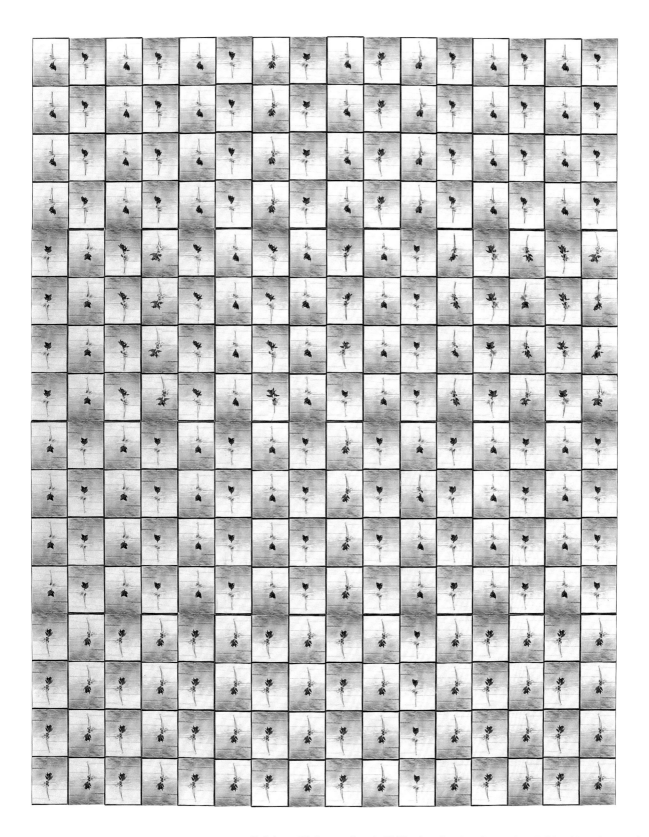

Hellebore (Christmas Rose), 2000, photo-booth strips on board, 32 x 25 1/4 inches

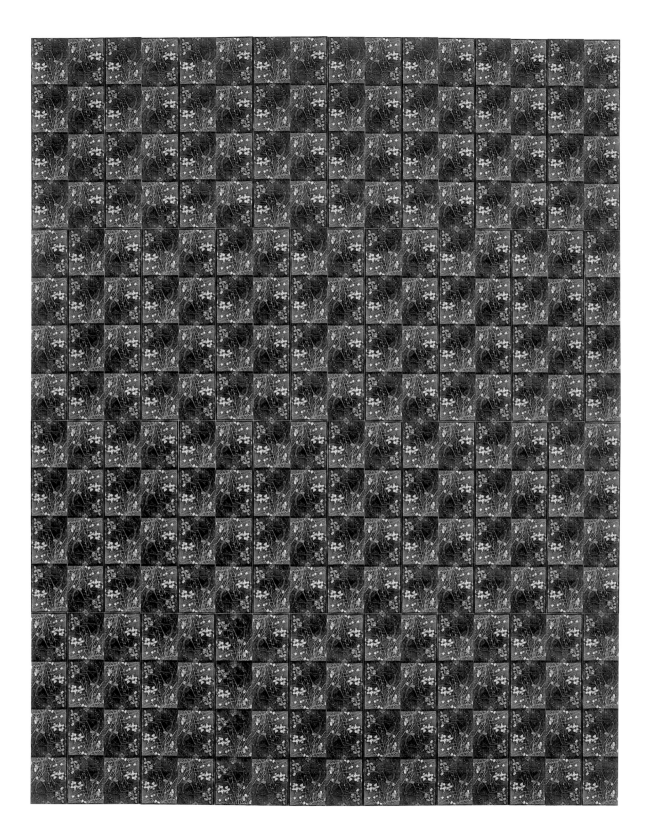

Kimono (Pussy Willow), 2000, photo-booth strips on board, 32 x 25 1/4 inches

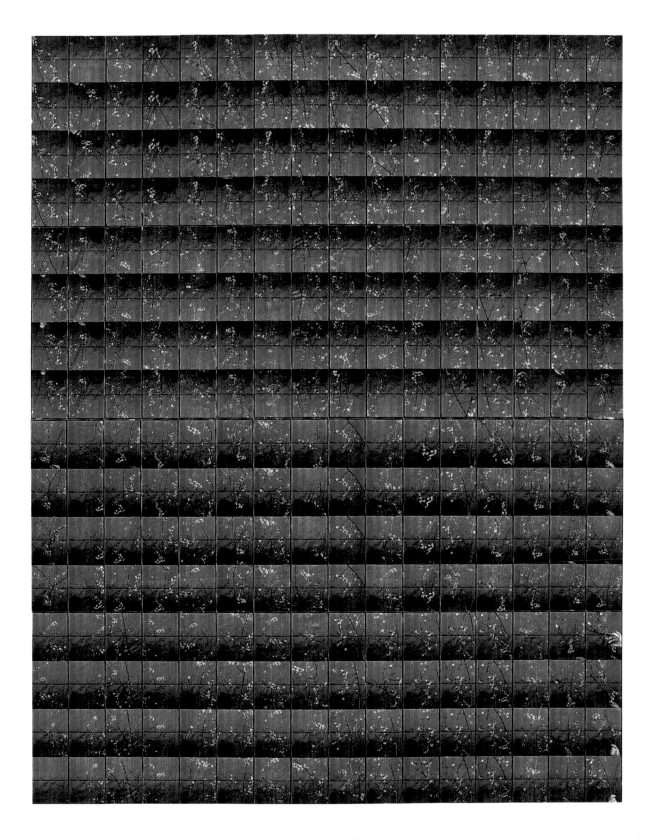

Japanese Snow, 2000, photo-booth strips on board, 32 x 25 1/4 inches

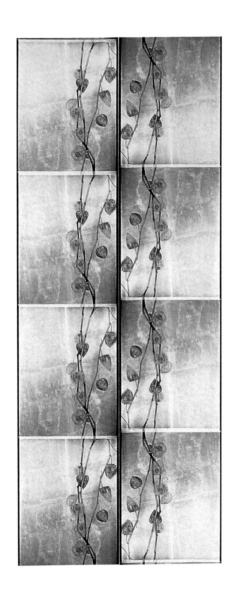

Kiss, 2000, photo-booth strips on board, 7 7/8 x 3 1/8 inches

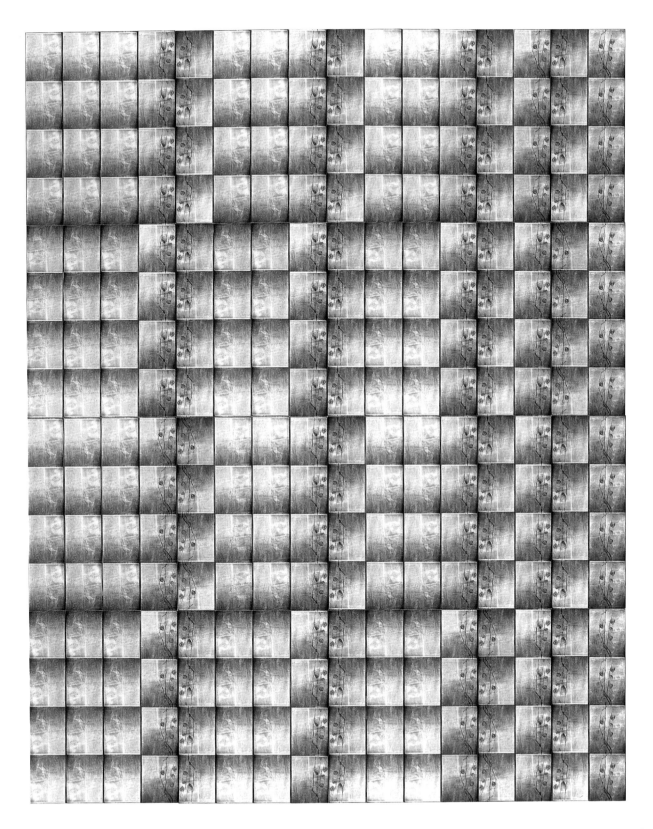

Pearly Queen, 2000, photo-booth strips on board, 32 x 25 1/4 inches

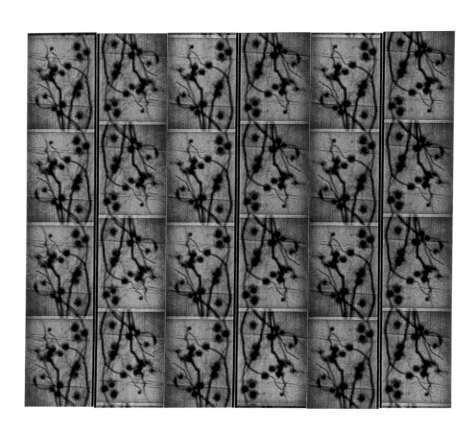

Wrought Iron Gate, 2001, photo-booth strips on board, 8 x 9 1/2 inches

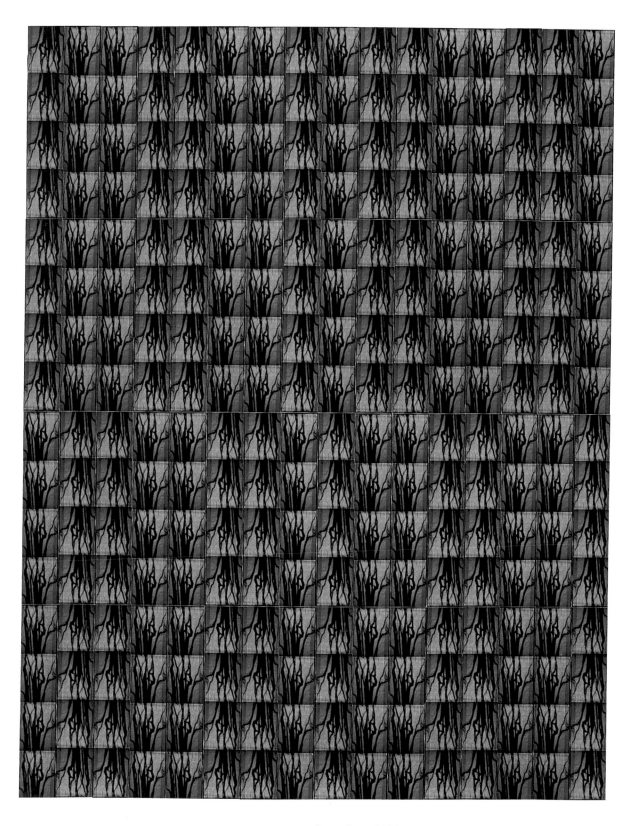

Poppy Root, 2000, photo-booth strips on board, 32 x 25 1/4 inches

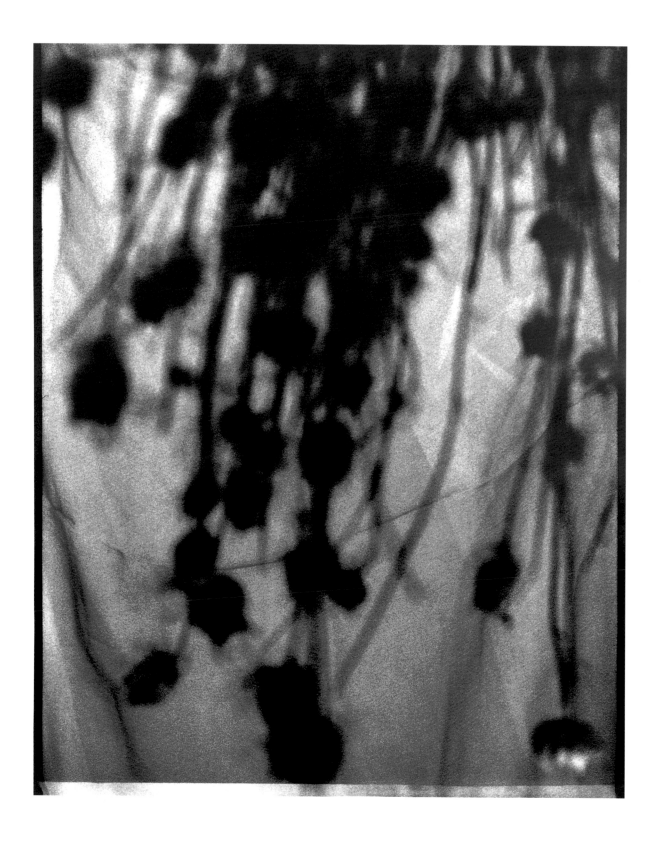

Nigella, 2000, C-print, 60 x 48 inches

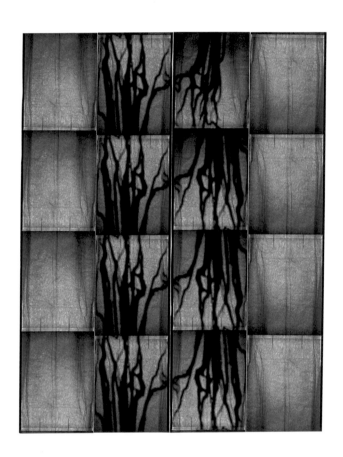

Shadow Poppy Root, 2000, photo-booth strips on board, 8 x 6 1/4 inches

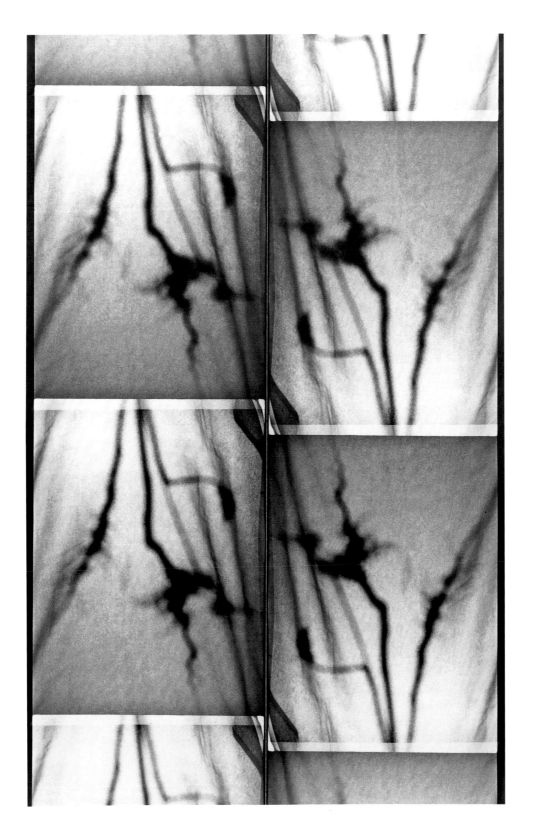

Wyang Kulit, 2000, C-print, 60 x 48 inches

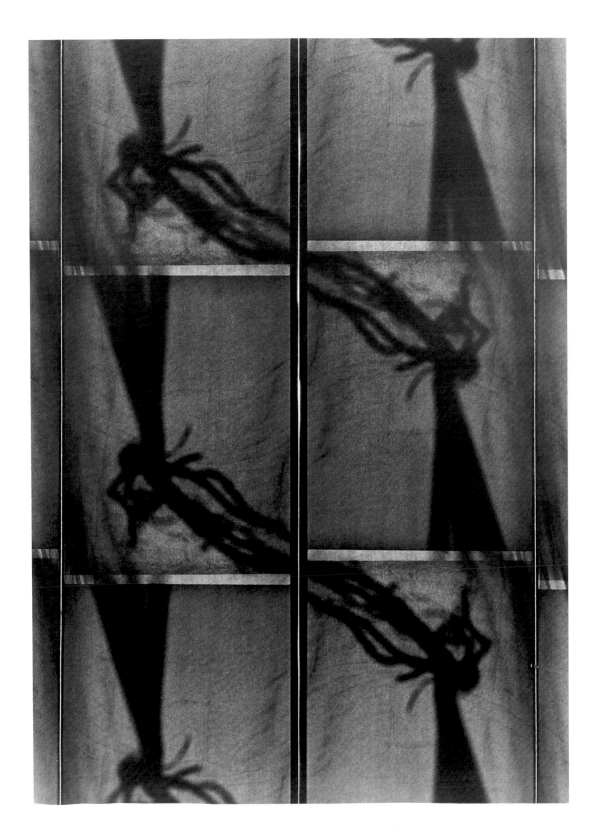

Sunny Gardens, 2000, C-print, 60 x 48 inches

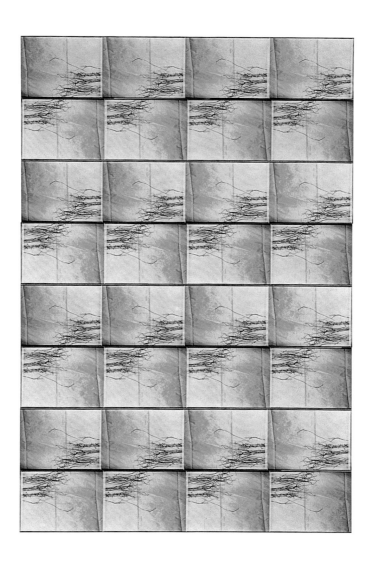

Radar, 2001, photo-booth strips on board, 12 1/2 x 7 7/8 inches

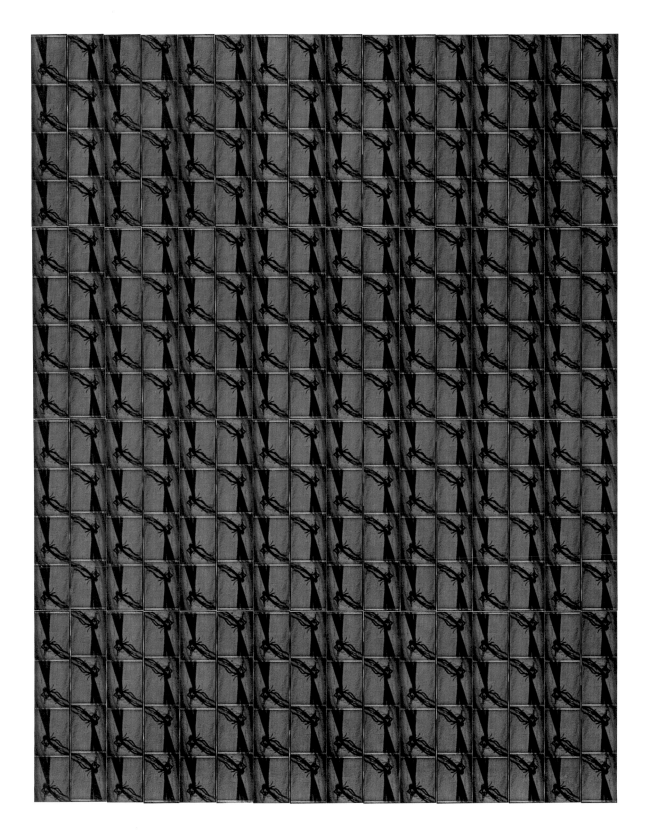

Flag, 2000, photo-booth strips on board, 32 x 25 1/4 inches

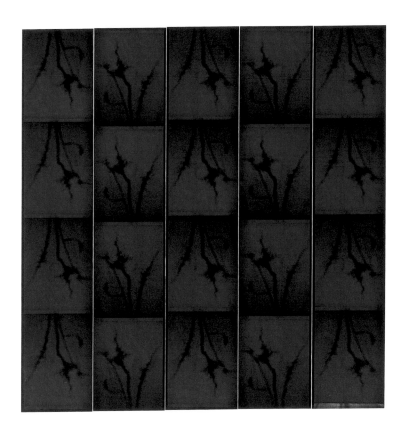

Fake Java, 2000, photo-booth strips on board, 8 x 7 7/8 inches

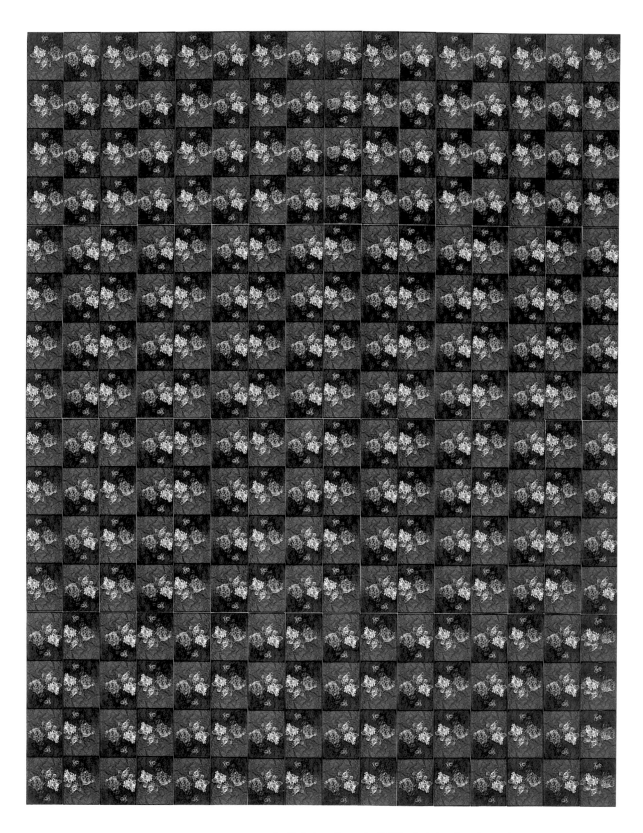

Fantin-Latour Homage, 2000, photo-booth strips on board, 32 x 25 1/4 inches

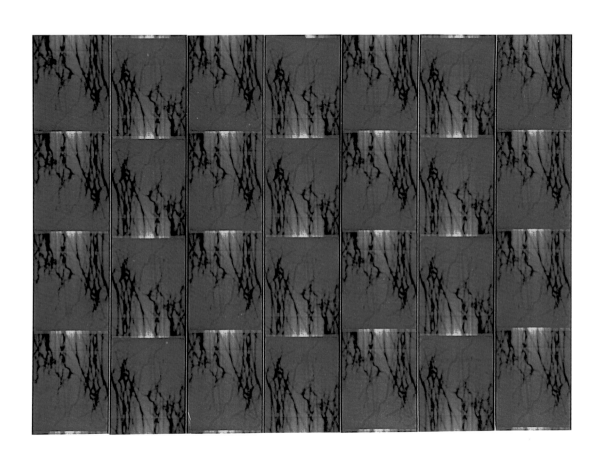

Desert, 2000, photo-booth strips on board, 7 7/8 x 11 inches

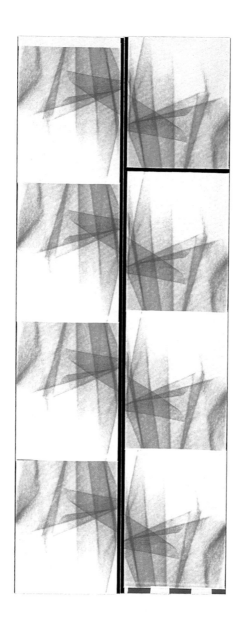

Hollywood, 1999, photo-booth strips on board, 8 x 3 1/8 inches

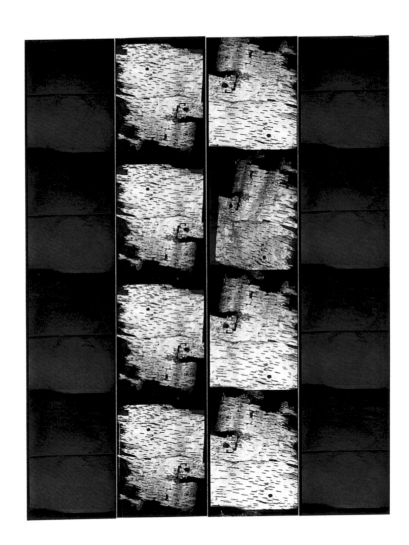

Mirror Mask (Silver Birch), 2000, photo-booth strips on board, 8 x 6 1/4 inches

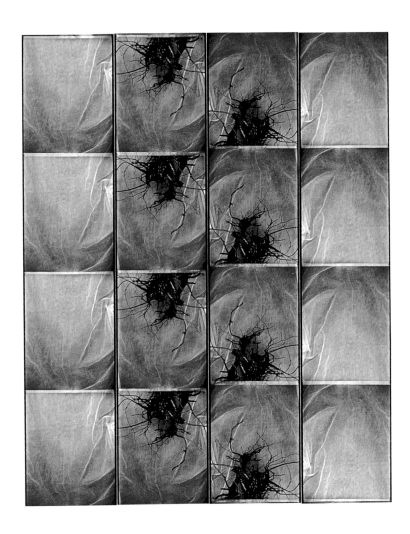

Spider Bed, 2000, photo-booth strips on board, 7 7/8 x 6 1/4 inches

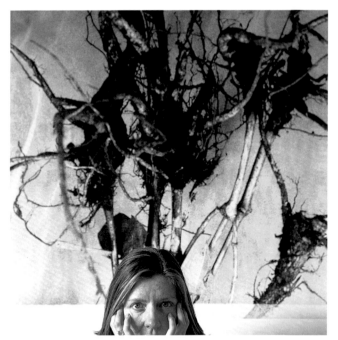

Born England 21.5.1954
Lives and works in London.

* indicates catalogue
2001 Lucas Schoormans, New York,
 Stills*

2000 Hiscox Gallery, E.C.3. Lignum/Silva,
 Lucas Schoormans, New York,
 Photographs 96 - 98
 Hackelbury Fine Art Ltd. Seasonal Stills

1999 The Ferens Art Gallery, Hull*,
 included new commission for the
 collection & curation of Girls, Girls, Girls
 works from the permanent collection.
 Focal Point Gallery, Southend
 Ramsgate Gallery, Up on Deck

1998 Angel Row Gallery, New Work*, Nottingham
 touring to Rochester Art Gallery, Kent
 The Photographers' Gallery, Originals

1997 Economist Plaza, London: Behind the Arras
 (with Julian Opie), organized by the
 Contemporary Art Society

1996 Institut Français, Edinburgh: Rainbow portraits

1995 Drew Gallery, Canterbury, Kent:
 Portrait progress

1994 British Film Institute, London: Picture parade

1992 Royal Photographic Society, Bath
 Spacex Gallery, Exeter
 Metropole Arts Center, Folkestone

1991 Vancouver Art Gallery, Canada
 Portfolio Gallery, Edinburgh
 Lythe Arts Center, Caithness
 Sunderland Polytechnic Gallery

1990 The Photographers' Gallery, London:
 Fairy Queen*
 The Orchard Gallery, Derry:
 The arbitrarinous line: line = map = division

1989 Cornerhouse, Manchester: Corner(House)
 Towner Art Gallery, Eastbourne: Seawall –
 Wave Motion

1988 City Museum & Art Gallery, Stoke-on-Trent:
 People Profile, Pillars of Society*
 University of Kent and The Zanzibar,
 London: Inked flowers

1986 Assembly Rooms, Edinburgh: Identity meets
 Tartan Castle

1985 The National Portrait Gallery, London: Identity

1982 Exe Gallery, Exeter, Devon: Bagatelles
 Végétales

2001 Cinema Studies,
Lucas Schoormans, New York

2000 Concerning the Photo-Booth*,
Museum of Photography, Denmark.

1999 Pacaembu: a planetary reply for the world*,
Oficina Cultural Oswald de Andrade,
Sao Paulo, Brazil

1998 50 Ans de Tati*, Musée des Arts
Décoratifs, Palais du Louvre, Paris
Mag Collection*, Fruitmarket, Edinburgh,
The Towner, Eastbourne & Cartright Hall,
Bradford.
Solo x 9*, Berry House, Clerkenwell, London
East Wing Collection*, Courtauld Institute,
London

Museums/Collections:

Arts Council of England
Bibliothèque Nationale, Paris
The National Portrait Gallery
Clock Museum, Bury St. Edmunds
Edinburgh District Council
The Reader's Digest
The National Poetry Library
Cambridge University Library
The National Art Library, Victoria
Washington Library of Congress
Bridwell Library Southern Methodist Unversity,
Dallas, Texas
The National Art Library, Victoria and Albert Museum
The Mag Collection
Henry Buhl Collection, New York
Vancouver Art Gallery, B.C. Canada
Progressive Corporation
The Seagram Collection
The Ferens Art Gallery
The Government Art Collection
(British Embassy, Paris)
Microsoft Art Collection
REM
Pfizer, Inc.

Commissions/Public Art Projects:

2000/1 Hippodrome Theatre, Birmingham -
12 metre stairwell hanging lantern &
outer glass theatre wall (15 x 8 metres)
etched with related imagery.
Lyon Town Hall, France. Projection :
48 x 23 metres onto the exterior wall of
the C17th building, commissioned by
Sculpture Urbaine, other artists included
Mary Kelly and Alfredo Jaar.

1998 Ferens Art Gallery, Willow Weep, set of
4 c-type prints for the collection.
Photoworks: 'Up on Deck', a portrait of
Ramsgate, Kent

1997 On the Edge. South East Arts Art
Project, Strood, Kent
Cascade. Sao Paulo projection in
collaboration with Sculpture Urbaine

1995 People Progress. St. George's
Underpass, Canterbury, Kent

1994 Picture Parade. British Film Institute

1991 Landscape of Experience. Vancouver Art
Gallery, British Columbia

1990 NCVO - National Council of Voluntary
Organisations. Sponsored by
British Telcom.
Trainload Freight, British Railways Board.
The Ivy Restaurant, London:
Hypnos & Endymion.

1988 The Evening Standard, 24/5, Lucinda Bredin.
The Guardian, 30/8, Pauline Willis.
People Profile - Pillars of Society: catalogue
supporting residency at Stoke-on-Trent
City Museum and Art Gallery; text Dr. Judy
Collins, Tate Gallery and Jim Shea,
Stoke-on-Trent

1989 Image Magazine, August. John Connolly.
The Sunday Times Magazine, 29/10,
Steve Turner.
The Independent, 24/10, Main photo:
Geraint Lewis.

1990 Lusus Naturae: The London series, Circle
Press publications; photographs by Rideal,
poem by Wendy Mulford
Photobooth collages: published by
Circle Press to coincide with the exhibition at
The Photographers' Gallery, London, text by
David Chandler
The Guardian, 13/5, Charles Hall.
Le Journal de C.N.R.S., April, Numéro 4.
cover image.
The International Herald Tribune, 3/8,
The Evening Standard Magazine, 6/8,
Lucinda Bredin.
London Log, November. No. 20.
Creative Camera, December.
Emmanuel Cooper.
Dictionary of British Art Vol.VI.
Twentieth Century Painters & Sculptors
Frances Spalding.

1991 Portfolio Magazine, Spring. No. 10.
David Chandler.
The Observer Magazine, 16/2,
Chloe Sayer.
The Guardian, 27/2, Sacha Craddock.

1992 The Independent on Sunday, 12/1,
Tom Lubbock.
Zoom, March No. 116. Margherita Heuser.

1993 Facing the page: British Artists' Books.
Cathy Courtney & Silvie Turner.

1994 Creative Camera, August. Emmanuel Cooper.
Kultur Liv, 9/7, Marianne Kleivan.
The Independent, 21/10, Genevieve Fox.
The Observer Review, 23/10, William Feaver.
Mapping Knowledge, 29/11, Les Bicknell.
F - Fotografisk Tildskrift No. 5., December.
Marianne Kleivan.
Woman's Hour Radio 4, 26/5, Interview.

1995 Village Voice, 25/7, Vince Aletti.

1996 The Guardian, 14/2, Jonathan Jones.
The List 3, 16/5, Juliet Knight.
Art Monthly No. 196 May, Mark Gisbourne.
Portfolio Magazine, June. Emmanuel Cooper.
Bomb (NY), Winter 96, 2 - page spread.
In Celebration Radio 4, 22/4, David Prest.
The Looking Book - A Pocket History of Circle
Press 1967 - 1996. Cathy Courtney.

1997 The Times, 15/5, Sacha Craddock.
Aperture Magazine, 1/10, Bill Hunt.
Engage, spring issue, Felicity Allen.

1998 Contemporary Visual Arts, Issue 20.
Keith Patrick.
The Guardian Guide 30/5 - 5/6.
The Big Issue, 20 - 26/7, Helen Sumpter.
Art Review, October. Rose Millard.
Creative Camera, June/July.
Emmanuel Cooper.
TimeOut London, 29/7 - 5/8, Tania Guha.

1999 The Independent on Sunday, 23/5,
Charles Darwent.
Make, July. Susan Bright.
Contemporary Visual Arts Issue 24,
Kirsty McGee.

2000 New York Times, 11/8, Ken Johnson.
New Yorker, 14/8, Gus Powell.
New York Magazine, 12/8, Edith Newhall.
The Independent on Saturday, 26/8,
Lisa Markwell.
TimeOut New York 31/8 - 7/9, Sarah Gavlak.
House & Garden, October, Moira Hodgson.
CNN tv, 6/9.
Focus, Artsworld tv, October.
TV-Fakta, Danish Broadcasting Corp.,
Kulturjournalen, 14/10.
British Journal of Photography, 2/10.
Galleries October, Mike Crawford.
International Herald Tribune, 15/11.
Politiken, 22/10, Per Munch.
Information, 28/11, Lisbeth Bonde.

ACKNOWLEDGEMENTS

Liz Rideal and Lucas Schoormans would like to thank
the following for their help and participation:

Frank St. Jacques
Andrea Schoormans
Charles Darwent
Norman Bryson
Nina Zurier
Toby Watley
Nic Barlow
Juliet Hacking
David Saywell
Charles D. Scheips, Jr.
Michael Dyer Associates
Hackelbury Fine Art Ltd.
Karl Peterson
and most especially: Clem Crosby

Liz Rideal would like to thank Photo-me International plc for their
generous sponsorship in kind since 1985.

Technical note:
All the works by Liz Rideal derive from the photo-booth. This com-
pact photographic studio has a 90mm lens and a fixed focus.
The positive film uses no negative, the sequence of four shots
takes 20 seconds. Developing happens inside the 'darkroom'
with standard developing chemicals. Images are as durable as
ordinary c-types.
The unique photo-booth strips measure 8 x 1 1/2 inches
(20.5 x 4 centimetres). These are mounted onto rigid museum
board with Lascaux acrylic adhesive 360 HV - light fast, elastic
and age resistant.
The larger works represent either collages of multiple originals or
edited photographic enlargements in c-type print form. These
enlargements are made by rephotographing the originals onto
10 x 8 inch stock using a 350 mm flat plane lens. The enlarge-
ments exist in editions of three.

Things, to their best perfection come,
Not all at once ; but, some and some.

ILLVSTR. XLV.

George Wither's Emblemes 1635

All works shown, unless credited otherwise,
are copyright of the artist.

Essays:
© Charles Darwent
© Norman Bryson
Photograph of Liz Rideal:
© Clem Crosby

Photography: Karl Peterson
Design: Andrea Schoormans
Production: Christian Kreher Grafische Werkstatt,
Bahruth Druck- und Medien GmbH
Publisher: Lucas Schoormans, on the occasion of
Liz Rideal, Stills, March, 13 - April 28, 2001

Cover images
Front: Elba, 2000, C-print, 60 x 48 inches
Back: Detail (Elba)

ISBN-No: 0-9708977-0-7

Lucas Schoormans
508 West 26th Street, 11B
New York, N.Y. 10001
tel: (212) 243.3159
fax: (212) 243.5069

Web addresses for further information:
www.oblidi.com
www.ucl.ac.uk/slade/rideal
www.artnet.com
info@lucasschoormans.com
international mail order: www.artbook.co.uk